Auguste Renoir

Patrick Bade

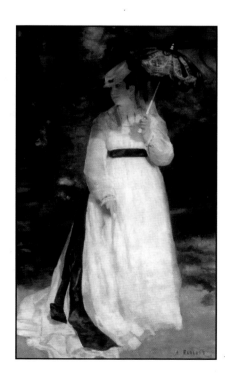

Publishing Director: Jean-Paul Manzo
Text: Patrick Bade
Design and layout : Cédric Pontes
Cover and jacket : Matthieu Carré

© Parkstone Press Ltd, New-York, USA,
2003
ISBN 1 85995 895 8

Printed and bound in Slovenia

Auguste
Renoir

Renoir loved women. This simple fact is the most important thing to know about his personality and his art. According to his son Jean, the distinguished film director, Renoir "bloomed both physically and spiritually when in the company of women." Even more than earlier European masters who had celebrated female beauty such as Titian, Rubens, Boucher and Ingres, Renoir was obsessed by the opposite sex. A glance through a catalogue *raisonné* of his work shows that depictions of women outnumber those of men many times over and that this ratio of women to men increased even further in later years.

1. *Lisa (Woman with a Parasol)*, 1867, Oil on canvas, 184 x 115 cm, Essen, Folwang Museum
2. *Self-Portrait*, ca. 1875, Oil on canvas, 36.1 x 31.7 cm, Williamstown (MA), Sterling and Francine Clark Art Institute

3. *Gabrielle with the Rose*, 1911, Oil on canvas, 55 x 47 cm, Paris, Musée d'Orsay

Through Jean Renoir's affectionate book Renoir, *My Father*, based on conversations between the two after Jean was invalided out of military service during the first world war, we know a great deal about Renoir's intimate thoughts and opinions concerning women. Much of what Renoir told his son at this time must have been recalled through a mist of nostalgia and Jean Renoir himself was less than totally accurate or truthful. Nevertheless, the book is of unique character and importance. No major nineteenth-century artist, even those who left diaries and extensive correspondence such as Delacroix, Pissarro and Van Gogh, was prepared to reveal as much of his intimate thoughts and opinions as Renoir did to his son Jean.

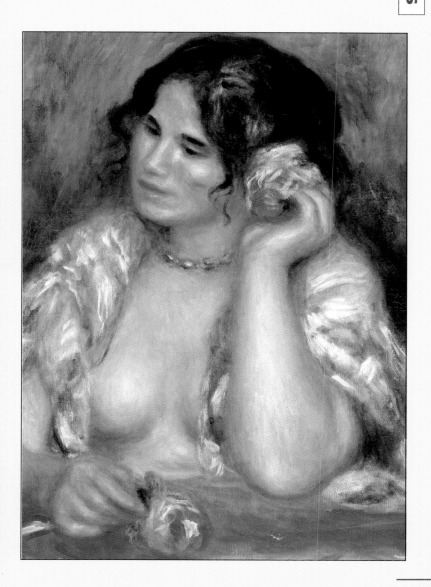

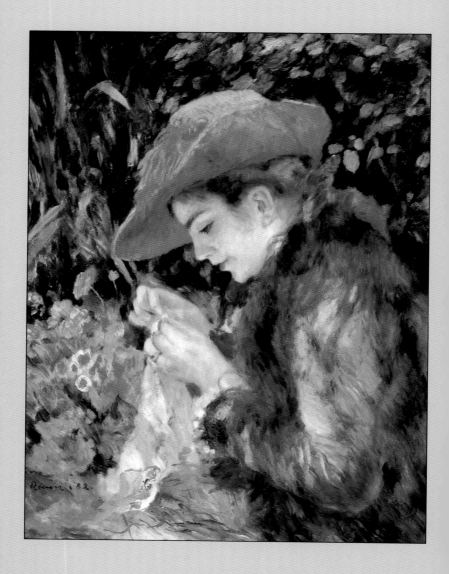

4. *Miss Marie-Therese Durand-Ruel Sowing*, 1882, Oil on canvas, 64.8 x 53.8 cm, Williamstown (MA), Sterling and Francine Clark Art Institute

Although Renoir loved women, he was never a womanizer. The casual promiscuity of a Delacroix who recorded the number of his conquests with crosses in his diary would have been unthinkable to Renoir. "I feel sorry for men who are always running after women," he told his son. "What a job! On duty day and night; not a minute's respite. I've known painters who never did any work because instead of painting their models they seduced them."

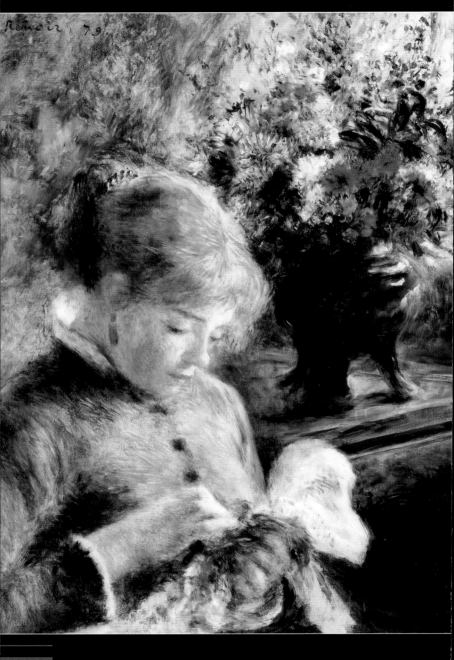

Renoir needed to be surrounded by women. In old age when he was crippled by arthritis, he rejected the suggestion that he should have a manservant to help him, saying: "I can't stand having anybody around me but women." But there was never the slightest suggestion of impropriety in the unconventional arrangements of the Renoir household with its small army of plump girls who alternated between doing domestic chores and taking off their clothes to pose for the Master.

5. *Young Woman Sowing*, ca. 1879, Oil on canvas, 61.5 x 50.3, Chicago (IL), Mr. and Mrs. Lewis Larned Coburn Memorial Collection

6. Gustave Courbet, *The Origin of the World*, 1868, Museum of Fine Arts, Budapest

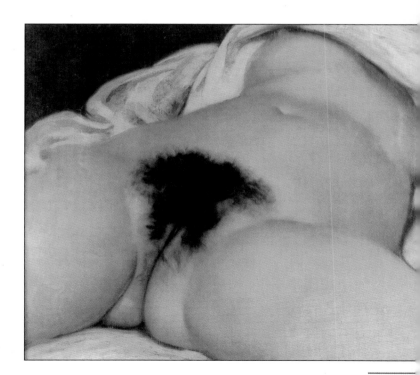

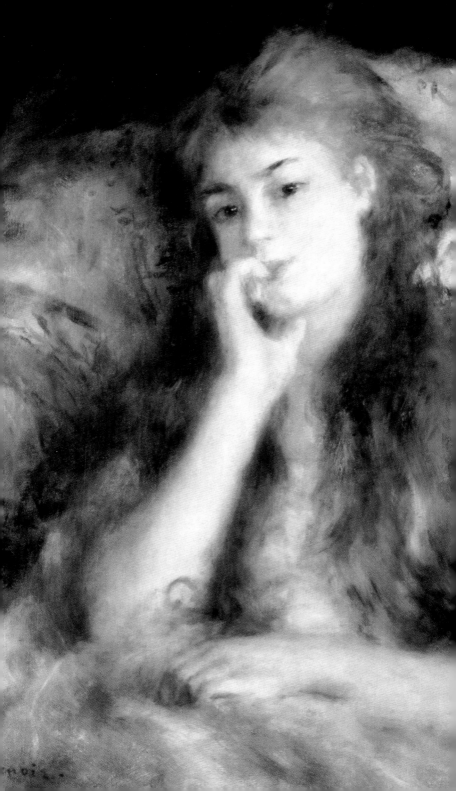

Despite his extreme love of women, Renoir's comments about them can seem to today's sensibilities even more offensive than the overtly misogynistic diatribes of his great contemporary Edgar Degas: "I can't see myself getting into bed with a lawyer...I like women best when they don't know how to read and when they wipe their baby's behind themselves," is a fairly typical example. Another is: "...the best exercise for a woman is to kneel down and scrub the floor, light fires, or do the washing; their bellies need movement of that sort." Not surprisingly, Renoir was not in favour of women's education: "Why teach women boring occupations such as law, medicine, science, and journalism, which men excel in, when women are so fitted for a task which men can never dream of attempting, and that is to make life bearable."

7. *The Thought*, ca. 1876-1877, Oil on canvas, 66 x 55.5 cm, Birmingham, The Barber Institute of Fine Arts, University of Birmingham

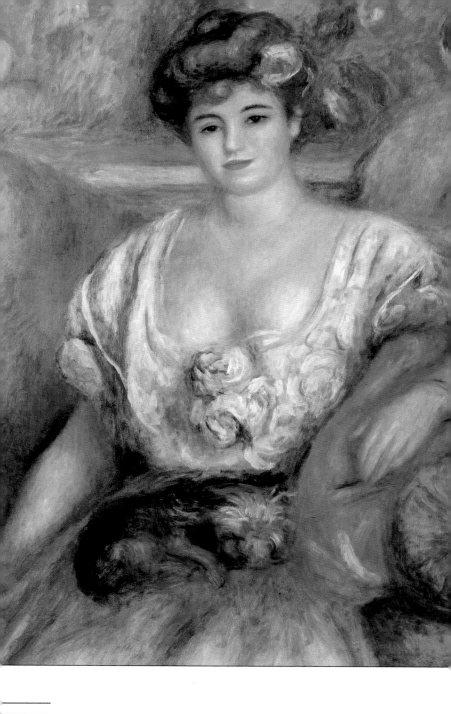

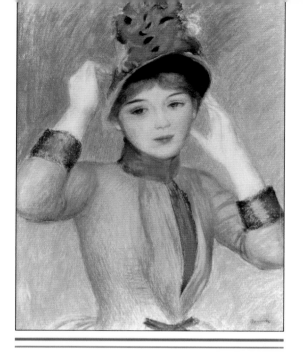

Nor was Renoir impressed by the pioneering achievements of feminism. "When women were slaves, they were really mistresses. Now that they have begun to have rights they are losing their importance." He expressed the curious idea that intellectualism and lack of physical exercise would lead to frigidity in women. "You'll find fewer and fewer of those pretty tarts who lose their heads when they give themselves completely. There's a risk that love-making, even the most normal, may become a kind of masturbation."

8. *A Woman's Bust, Yellow Corsage*, ca. 1883,
Oil on canvas, 42 x 32 cm, Private Collection
9. *Portrait of Miss Misia Edwards (Misia Sert)*, 1907,
Oil on canvas, 92 x 73.5 cm, Merion (PA),
The Barnes Foundation

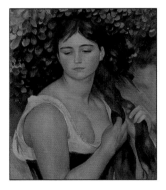

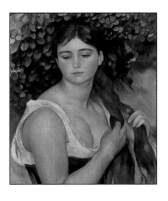

Renoir's feminine ideal was of placid vacuity. He would deliberately engage his models in the most banal conversation in order to induce the kind of empty expression he wanted. He was outraged when a dealer dubbed one of pictures "La Pensee" exclaiming "My models don't think at all." Despite his preference for women who could not read, and his assertion that reading was a "vice worse than alcohol or morphine," Renoir posed several of his models with books. However, we never believe that they are actually reading the volumes they hold so listlessly. In this regard, they are in marked contrast with the many eighteenth-century depictions of aristocratic blue-stockings with books such as Liotard's *Mme d'Epinay* whose alert expression and superior smile convinces us that she could really understand the text by Newton she displays so ostentatiously. And in Drouais' *Mme de Pompadour*, she sits in front of a bookcase filled with volumes of Diderot's *Encyclopaedia*.

10. *The Braid (Suzanne Valadon)*,
1884-1886, Oil on canvas,
56 x 47cm, New York, The
Metropolitan Museum of Art,
Mr. and Mrs. Henry Ittleson, Jr., Fund

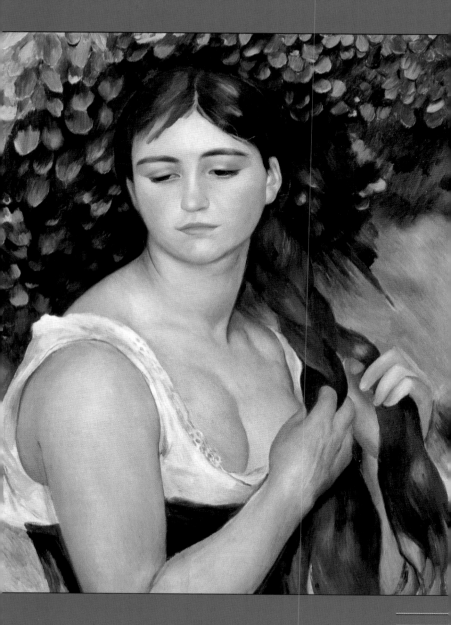

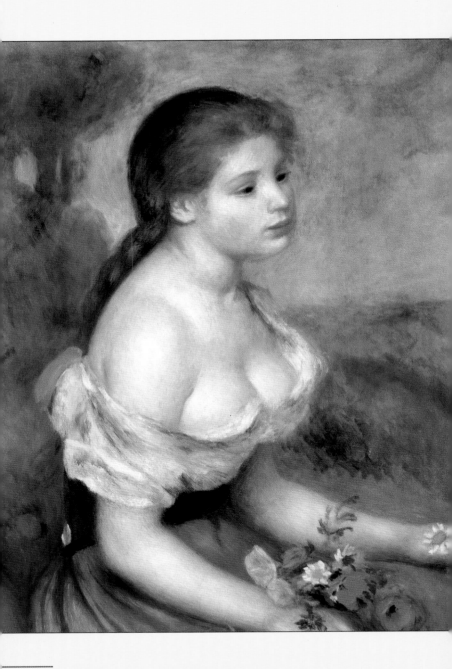

Renoir's comments about women should be understood in the context of his time, when such opinions were far from unusual. We should perhaps not judge him too harshly. He not only loved women, but more remarkably perhaps, he liked them too. He was capable of sharing lifelong and devoted friendships with intelligent women such as the painter Berthe Morisot and the beautiful Misia Sert or Mme Edwards as she was known when she posed for Renoir in several portraits. According to Jean Renoir, his father's friendships with women "however tentative and delicate were always on the point of turning into something more romantic." We can detect this in Renoir's surviving letters to Mme Edwards. On July 3, 1906, he wrote to her: "Come, and I promise you that in the seventh portrait I shall try to make you even more beautiful. I am well and I'll feel even better if you can come to see me in Essoyes-Aube this summer...I shall do everything I can to show you amusing things and we'll eat as well as possible."

11. *Young Girl with Daisies*, 1889, Oil on canvas, 65.1 x 54 cm, New York, The Metropolitan Museum of Art, Mr. and Mrs. Henry Ittleson, Jr., Fund

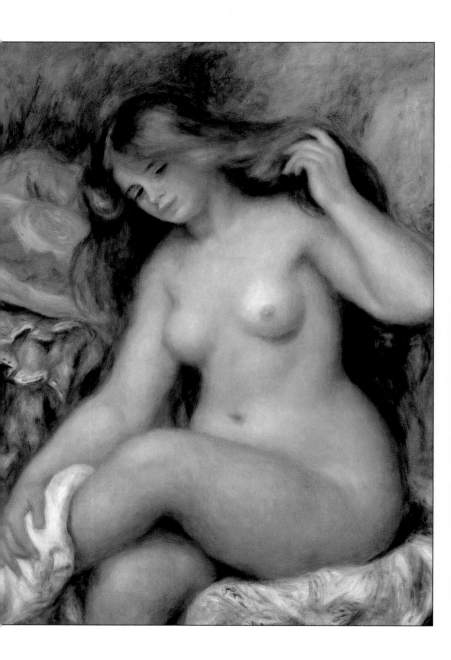

12. *The Bather*, ca. 1909, Oil on canvas, 92.7 x 73.4 cm,
Vienna, Österreichische Belvedere Gallery

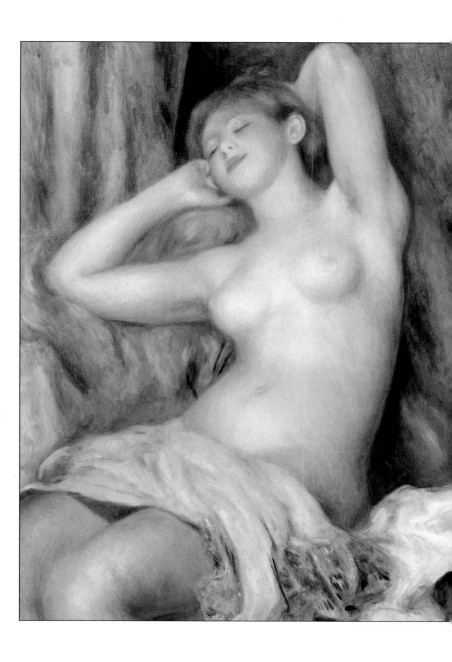

13. *The Sleeper*, 1897, Oil on canvas, 82 x 66 cm,
Winterthur, Oskar Reinhart "Am Römerholz" Collection

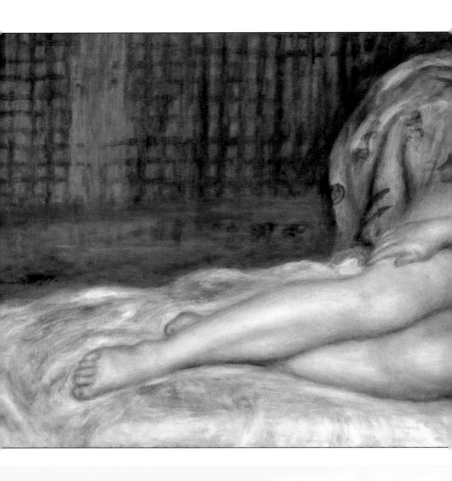

More indiscreet letters from Renoir were apparently destroyed, but Renoir's age and frailty, in addition to the vigilance of Misia's jealous husband, precluded the possibility that the relationship between Renoir and Misia was ever more than an *"amitie amoureuse."*

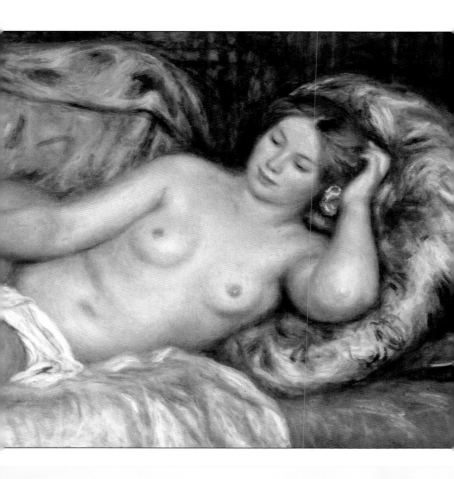

Renoir's preference for a distinctive physical type lent a certain family resemblance to all his female and child subjects. Jean Renoir said that he had the feeling of looking at a dead sister when he saw the portraits his father had made of actress Jeanne Samary who was one of that "immense family" of the artist's preferred sitters.

14. *Nude on Cushions*, 1907, Oil on canvas, 70 x 155 cm, Paris, Musée d'Orsay

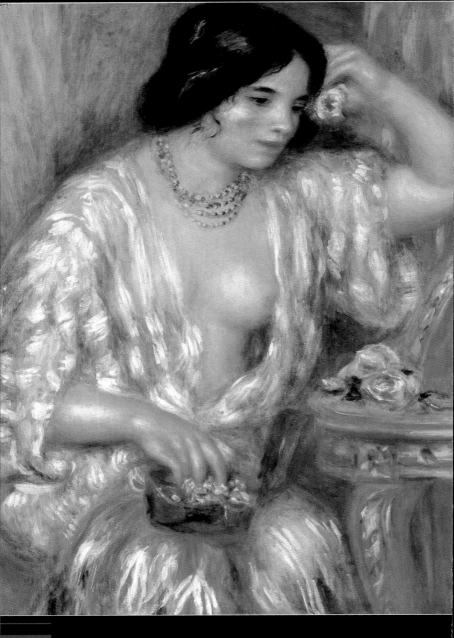

15. Gustave Courbet, *Sleepiness or Laziness and Luxury*, 135 x 200 cm, Paris, Musée du Petit Palais
16. *Gabrielle with Jewels*, ca. 1910, Oil on canvas, 81 x 65 cm, Geneva, Private Collection

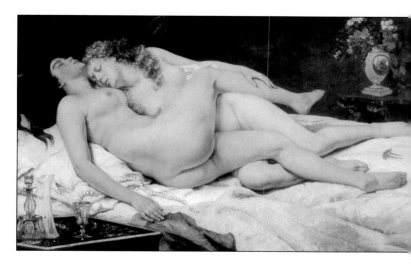

The Renoir "type" was plump and well-rounded, with a shape that translated easily into the large simple volumes of his later work. (Such was Renoir's love of rounded forms that one cannot help feeling that his compulsion to round off the sharp corners of the household furniture stemmed as much from aesthetic preference as from a desire to protect his small children.)

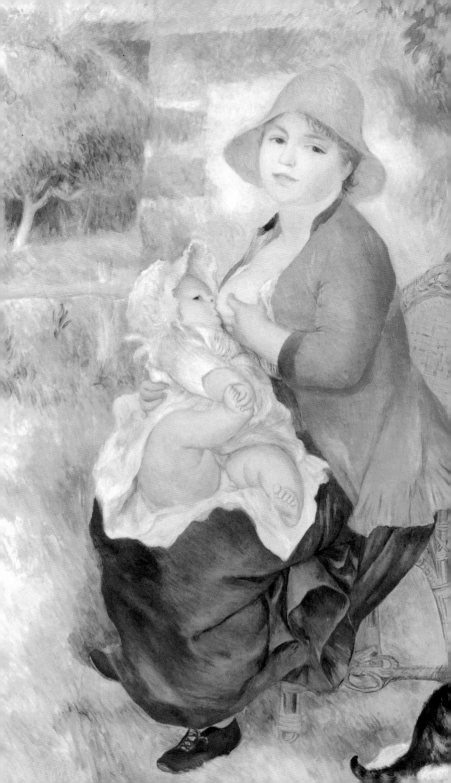

The ideal Renoir woman had a broad face with wide-set eyes, full lips, and a short, up-turned nose. He had a preference for blondes and a passion for pearly skin that "took the light," inspiring those delicate nacreous passages of paint that are amongst the chief delights of his work. Though some of Renoir's female portraits are amongst the loveliest ever painted, he was not a great portraitist in the sense of being able to capture individual likeness or personality. Even the Habsburg profile of Marie Antoinette where he reproduced her likeness on porcelain plates at the beginning of his career, conforms to the Renoir type with the shortened nose.

17. *Maternity – The Child Breastfed (Aline and Pierre)*, Third version, 1886, Oil on canvas, 74 x 54 cm, Private Collection

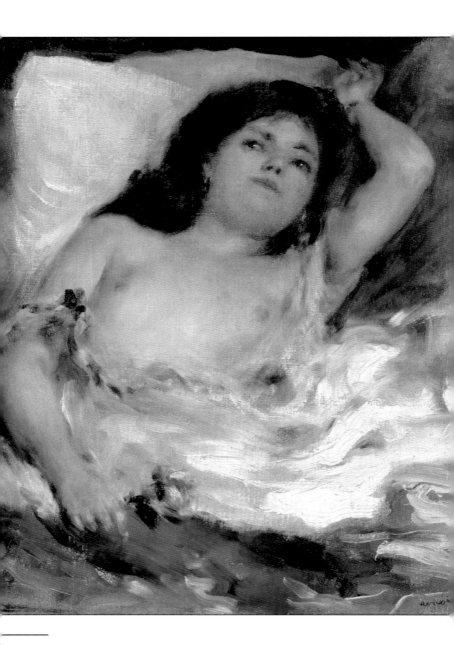

Although Renoir was never a hair fetishist to the same degree as that of his friend Degas or the Pre-Raphaelite artist Dante Gabriel Rossetti, he nevertheless loved to paint women's hair. Just as he loved skin that "took the light," he loved the glint of light on hair. In an age when respectable women were always seen in public with their hair elaborately coiffed, Renoir was typical in experiencing an erotic frisson from the sight of abundant, unrestrained hair, with its connotations of surrender and sexual adventure. Like Degas, Renoir frequently painted women drying, combing, and arranging their hair. At the very end of his life, he reminisced about one of his first mistresses, a certain Berthe, "a superbly healthy blonde, one of those girls with unruly hair who spends her time putting her chignons in order."

18. *Half-naked Woman Lying Down: the Rose*, ca. 1872, Oil on canvas, 28 x 25 cm, Paris, Musée d'Orsay

"Don't trust anybody who doesn't get excited at the sight of a pretty breast." Renoir warned his son as he remembered his own youthful excitement at the sight of the low-cut bodice of his employer's wife when he worked as a decorator of porcelain plates. Renoir's pleasure at the sight of firm and plump breasts is abundantly clear in countless paintings. In *Sleeping Woman* (1897), today in the Oskar Reinhart Collection at Winterthur, the girl raises her arms behind her head, like Marilyn Monroe in a pose calculated to display her breasts to the best advantage. There are several paintings for which Renoir stood behind the seated model to allow the viewer to share in the illicit delight of peering down an ample cleavage.

19. *Young Girl with a Cat*, 1880, Oil on canvas, 120 x 94 cm, Williamstown (MA), Sterling and Francine Clark Art Institute.

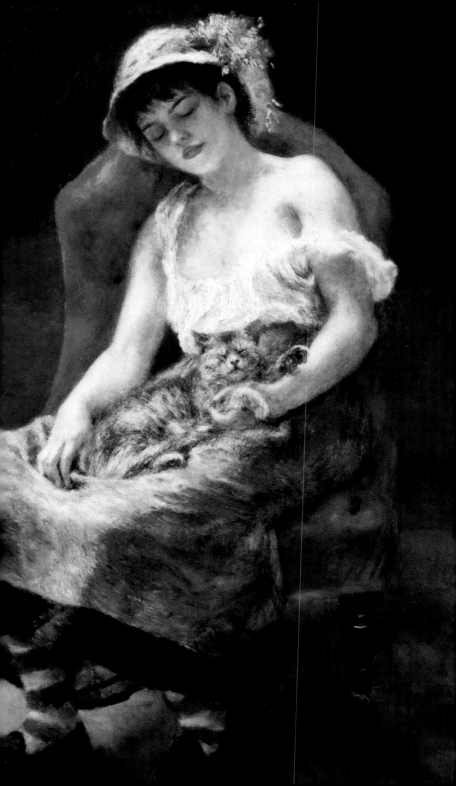

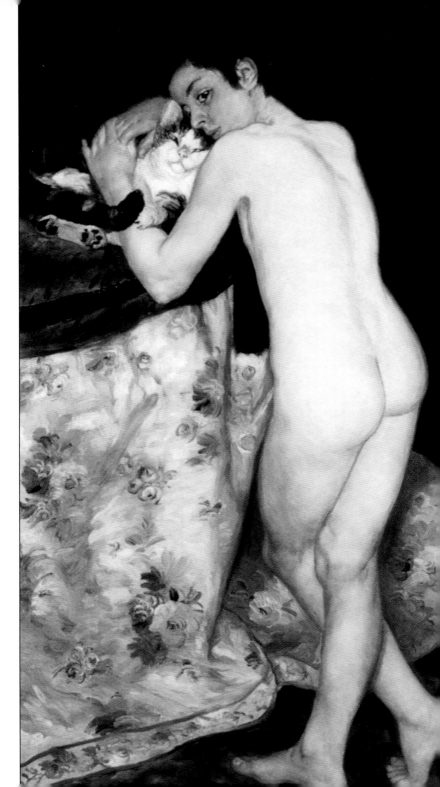

Such verbal descriptions might make Renoir sound prurient and sleazy. On one level, a painting such as *Sleeping Woman* is not so different from a centrefold pin-up. We never believe for a minute that she really is asleep. She displays herself deliberately for the pleasure of the male viewer. Yet there was never a painter less prurient than Renoir.

20. *Young Boy with a Cat*, 1868, Oil on canvas, 124 x 67 cm, Pars, Musée d'Orsay
21. *Woman with Cat*, ca. 1875, Oil on canvas, 57 x 46.4 cm, Washington (DC), National Gallery of Art, Gift of Mr. and Mrs. Benjamin E. Levy

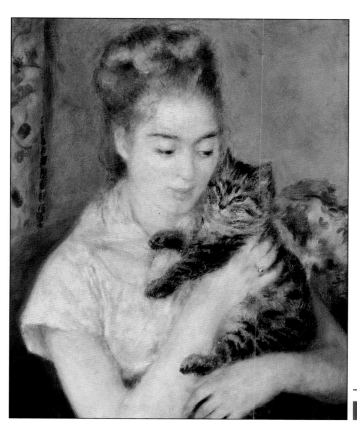

His nudes have an earthiness and simplicity that is worlds away from the pretty girls painted by the popular Salon artists of the day, who seem lubricious even when fully clothed. The difference lies above all in their facial expressions. Renoir's girls do not ogle and flirt with the viewer like those of Bouguereau or Cabanel.

The essential simplicity and innocence of Renoir comes across in countless anecdotes recounted by his son Jean based on conversations he had with his father towards the end of his life. For a man who spent much of his working life surrounded by nude models who would have been regarded by most of his contemporaries as little better than prostitutes, he was curiously shy when it came to talking about sex. He disliked "off-colour" stories and jokes, particularly in front of young girls, and always treated his models with the greatest respect.

At the same time, he had no patience with euphemism and prudery and could be startlingly earthy and direct in his own speech. On one famous occasion when a journalist tactlessly asked how he managed to paint with his crippled hands, Renoir answered crudely: "With my prick." It was an answer that probably contained more truth than the artist intended, as it is possible to see all of Renoir's art as an expression of sublimated sexuality. When talking of painting, he would often use sexual metaphors such as to "caress and stroke the motif."

22. *Jeanne Samary*, 1877, Oil on canvas, 46 x 44 cm, Paris, Musée de la Comédie-Française

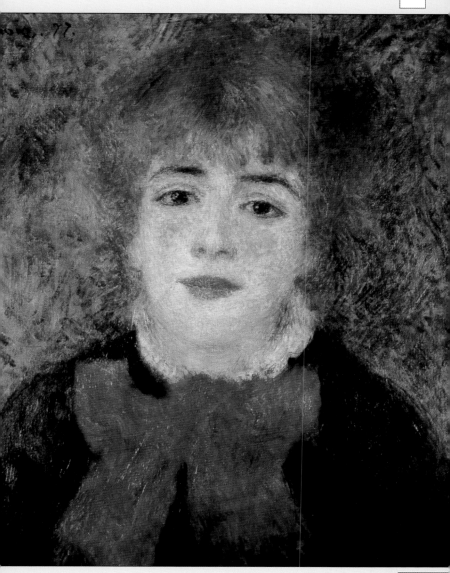

Another endearing and characteristic anecdote told by Jean, showing Renoir's bluntness, concerns the great operetta diva Hortense Schneider, who had seduced all of Paris and the crowned heads of Europe with her interpretation of Offenbach's Grand Duchess of Gerolstein in 1867. "One day in her dressing-room, Zola and my uncle Edmond were discussing "the theme in painting." My father began to grow restless and, turning to Hortense Schneider, who for her part could hardly conceal her yawns, he said, "That's all very fascinating, but let's talk of more serious things. How is you bosom these days?" "What a question!" answered the diva, smiling.

23. *The Reading of the Part*, 1874-1876, Oil on canvas, 9 x 7 cm, Reims, Musée des Beaux-Arts

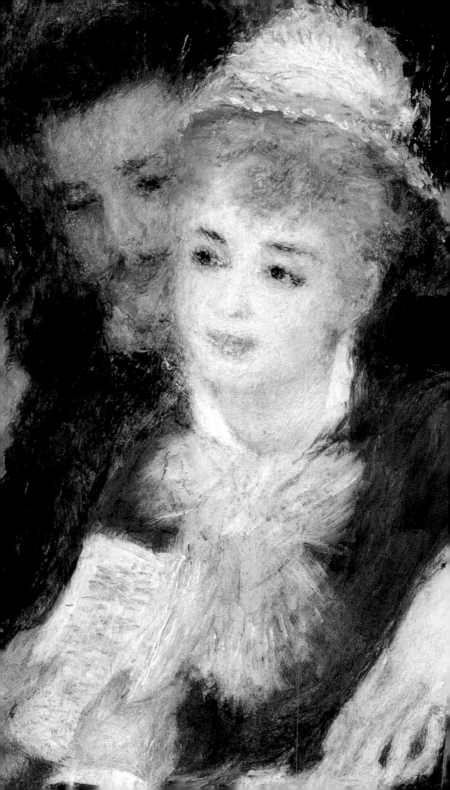

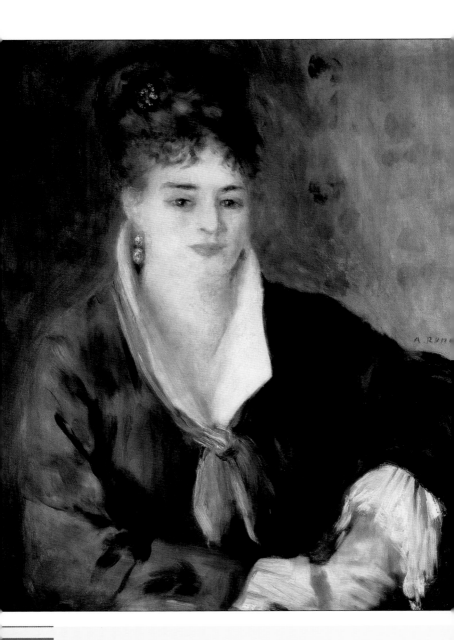

Then she opened her bodice and gave him dazzling proof of the excellent condition of her bodily charms." He had strong opinions about the necessity of breastfeeding babies, "not only because mother's milk has been invented, but because a child should bury its nose in its mother's breast, nuzzle it, and knead it with its chubby hand." He was convinced that depriving children of the breast would be "paving the way for generations of the mentally deranged".

In her memoirs, Misia gave a sadder account of the aged Renoir begging to see her breasts while she posed for a portrait:

"Lower, lower, I beg you," he insisted. "My God! Why won't you your breast? It's criminal!" "Several times I saw him on the verge of tears when I refused. No one could appreciate better than he the texture of skin, or, in painting, create such rare pearl-like transparency. After his death I often reproached myself for not letting him see all he wanted. In retrospect, my prudishness seems to me stupid, since it was a question of an artist whose extraordinary eye suffered terribly when he was not allowed to see what he guessed was beautiful."

24. *Lady in Black*, ca. 1876, Oil on canvas, 63 x 53 cm, St Petersburg, Hermitage Museum

For Renoir the female breast signified not only sexuality but also maternity. He loved to paint nursing mothers or mothers with young children. Whether by accident or by design, the births of his three sons were spread over a period of sixteen years from 1885 to 1901, thus providing him with half a lifetime of this subject matter within his own household.

When they are not depicted nursing or playing with children, Renoir's girls are likely to be seen fondling a cat. The iconography of women and cats in nineteenth-century French art is complex and fascinating.

25. *The Judgment of Pâris*, 1914, Oil on canvas, 73 x 92.5 cm, Hiroshima, Hiroshima Museum of Art

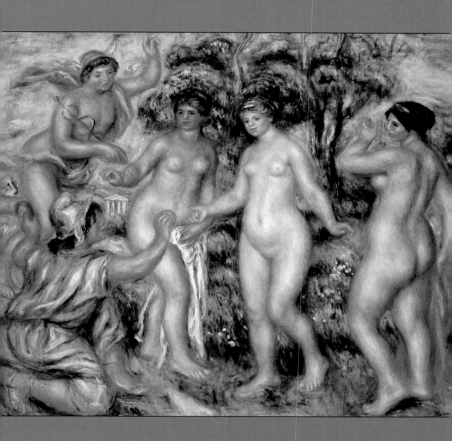

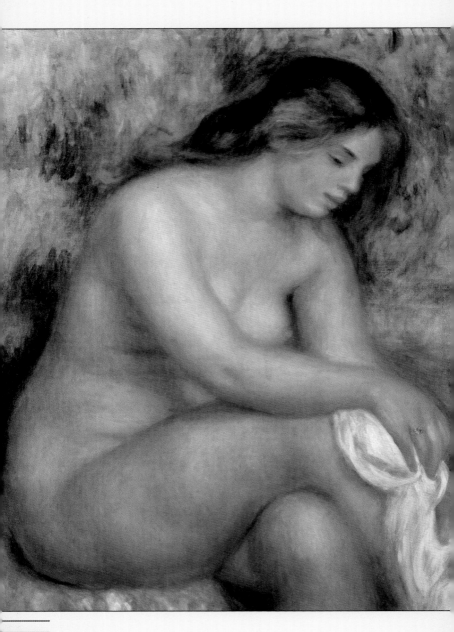

Renoir cannot have been unaware of the popular usage of *chat* for the female pudenda, nor of the sexual connotations of the cats in Manet's *"Olympia"* and in Toulouse-Lautrec's images of the English chanteuse May Belfort who delighted Parisian audiences with her lewd parody of an Anglo-Saxon virgin, dressed in a little girl's nightdress and clutching a cat as she sang "I've got a little cat and I'm very fond of that." Symbolist poets and painters made much of a supposed affinity between women and cats. The Belgian artist Fernand Khnopff fused a woman and a panther into one menacing, sphinx-like creature in his picture, *Des Caresses* of 1896. For Salon painters in the 1890s it became a cliché to pose their nudes on tiger or lion-skin rugs. Actresses and dancers who wished to cultivate the image of the "femme fatale" rushed to acquire exotic cats as pets. Sarah Bernhardt took a lion into the private menagerie in her Parisian house until it became too smelly. Ida Rubinstein liked to be seen walking a panther on a leash until it attacked her in her own bedroom to the consternation of Debussy and D'Annunzio who were waiting downstairs to meet her.

26. *The Bather Wiping her leg*, ca. 1910, Oil on canvas, 84 x 65 cm, São Paulo, Museu de Arte de São Paulo, Assis Chateaubriand

Renoir had no time for Symbolist decadence or the fin-de-siecle cult of the "femme fatale". He made a point of his own down to earth normality. When he felt he was being over-praised, he would retort "Who? Me? A genius? What rot! I don't take drugs, I've never had syphilis, and I'm not a pederast." In women too, what he prized above all was normality and good health. The tubercular look affected by fashionable, literary women had no attraction for him: "You'd have to pay me to sleep with the Dame aux Camelias," he said.

27. *Young Woman Bathing*, 1888, Oil on canvas, 85 x 66 cm, Private Collection

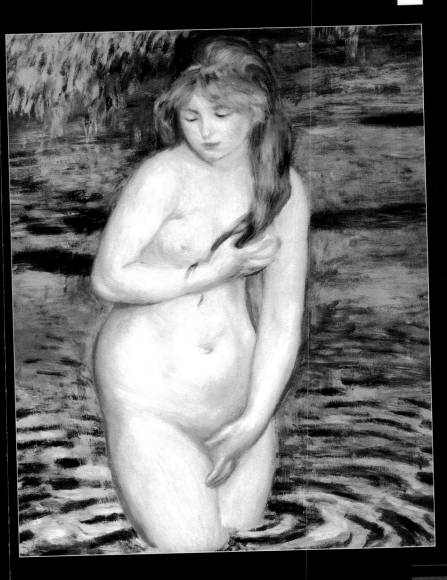

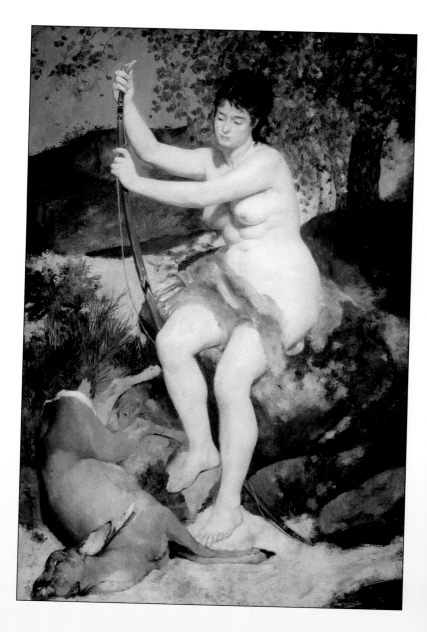

28. *Diane the Huntress*, 1867, Oil on canvas,
199.5 x 129.5 cm, Washington (DC),
National Gallery of Art, Chester Dale Collection

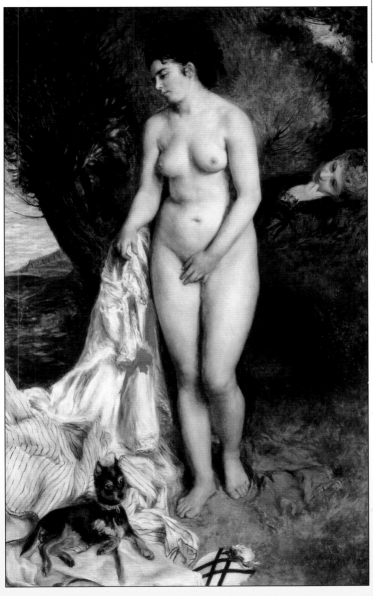

29. *Bather with a Griffon*, Oil on canvas, 184 x 115 cm,
Sâo Paulo, Museu de Arte de Sâo Paulo,
Assis Chateaubriand

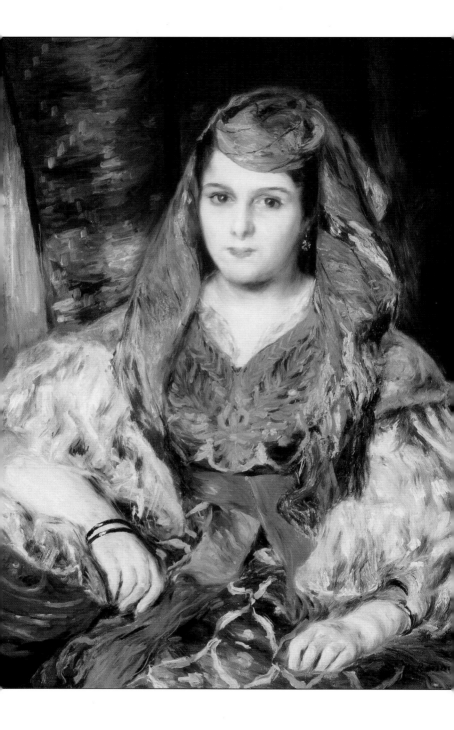

30. *The Algerian (Madame Clémentine
Stora in an Algerian costume),* 1870,
Oil on canvas, 84.5 x 59.6 cm, San
Francisco (CA), Fine Arts Museum,
Gift of Mr. and Mrs. Prentis Cobb
Hale in honor of Thomas Carr Howe
Jr.

31. *Odalisque (Woman of Algiers),* 1870,
Oil on canvas,
69.2 x 122.6 cm, Washington (DC),
National Gallery of Art, Chester Dale
Collection

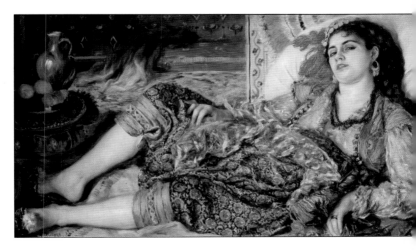

It was the playful rather than the predatory aspect of cats
that appealed to Renoir and what he liked to associate
with women. When enthusing about Jean Goujon's
carved reliefs on the Fontaine des Innocents, probably the
first great work of art that he saw as a child, Renoir said,
"Those women Jean Goujon carved have something of
the cat about them. Cats are the only women who count,
the most amusing to paint." He classified his own wife
Aline Charigot as belonging to the cat type saying, "You
wanted to tickle her under the chin."

If Marie-Antoinette with a turned-up nose was Renoir's first great female subject, Renoir soon progressed to Venus. His first attempt at painting on a larger scale was a mural of Venus rising from the waves painted on a café wall. In later years, Renoir tended to avoid Venus as a subject, perhaps because she had been tarnished by appearing too often on the walls of the Salon, depicted by artists such as Bouguereau, Cabanel, and Gervex, although he did tackle the time-honoured subject *the Judgement of Paris*, and we can detect an echo of *the Venus Pudica* in the delightful *Jeune femme se baignant* of 1888.

32. Eugène Delacroix (1798-1863), *Women of Algiers*, 1834, Oil on canvas, 180 x 229 cm, Paris, Musée du Louvre

33. *Interior of a Harem in Montmartre (Parisian Women Dressed in Algerian costumes)*, 1872, Oil on canvas, 156 x 128.8 cm, Tokyo, National Museum of Western Art, Matsukata Collection

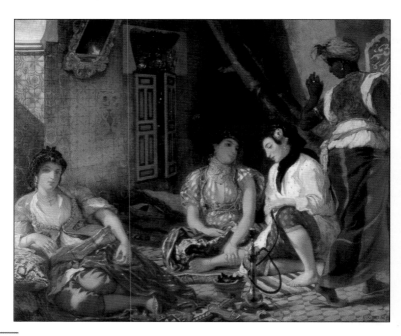

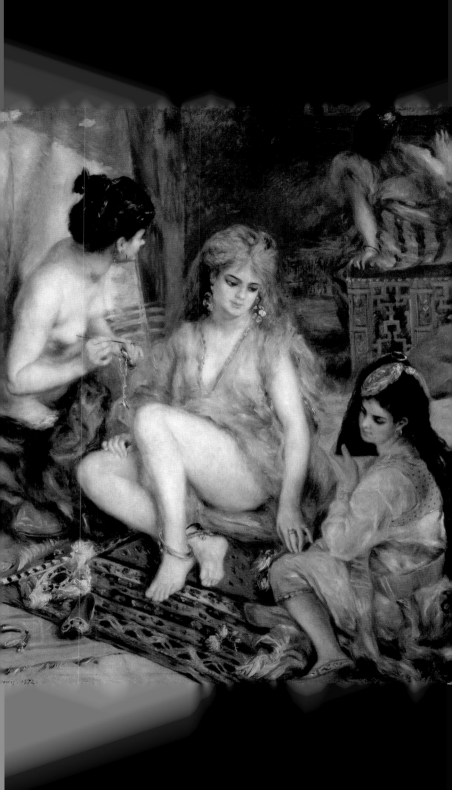

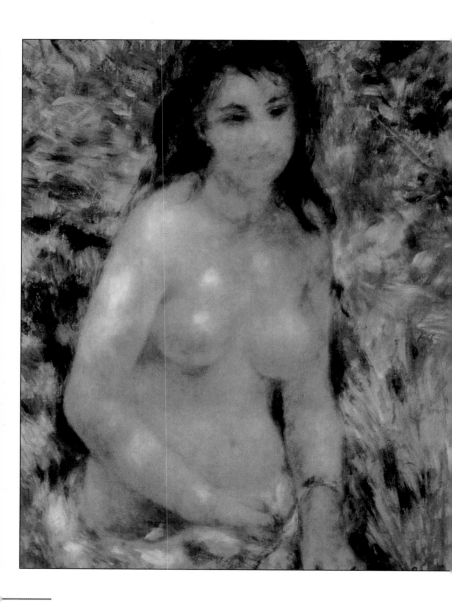

Once Renoir had made the decision to devote his life
to painting, he followed the conventional course of
applying to the Ecole des Beaux-Arts in 1862 and at
the same time, enrolling in the studio of the
respected Swiss painter Charles Gleyre, where he met
Monet, Sisley, and Bazille, the nucleus of the future
Impressionist group. Both Renoir and Monet were
later dismissive of Gleyre, with Monet claiming less
than truthfully: "We left after two weeks of this kind
of proficiency. We were well rid of it." In fact, Renoir
stayed a good two years with Gleyre and certainly
benefited from the opportunity to draw and paint
after nude models, a practice forming the basis of
academic art education in the nineteenth century,
even if the models were often male rather than
female. As a corrective to the dryness of the method
taught by Gleyre, Renoir developed an enthusiasm
for two very different painters of the previous
generations, Courbet and Delacroix. The influence of
both can be detected in Renoir's work as late as the
early 1870s. The influence of Courbet is apparent in
Renoir's impressive but unsuccessful Salon
submission in 1867, *Diana the Huntress*. The salon
jury was no doubt offended by the bold application
of paint with a palette knife, in the manner of
Courbet, and by the solid and rather plebeian
appearance of the goddess. The model for this picture
was Renoir's mistress Lise Trehot who posed that year
wearing clothes in the sunlight for a picture that
shows the young Renoir beginning to share his friend
Monet's interest in plein-air effects of light.

34. *Nude in the Sun*, 1875, Paris, Musée d'Orsay

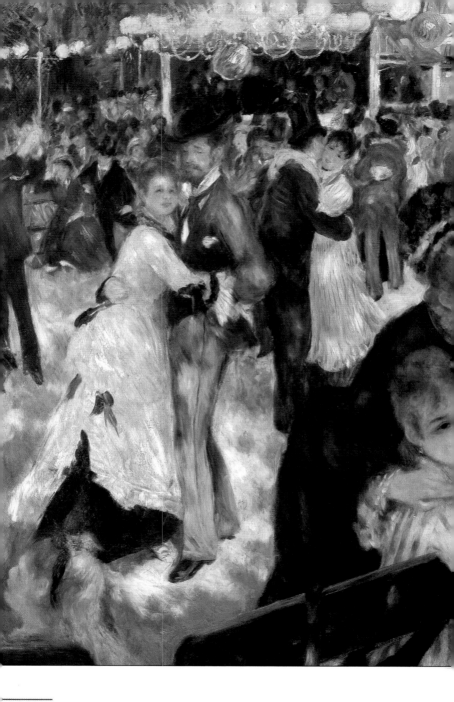

35. *The Bal at the Moulin de la Galette*, 1876,
Oil on canvas, 131 x 175 cm, Paris, Musée d'Orsay

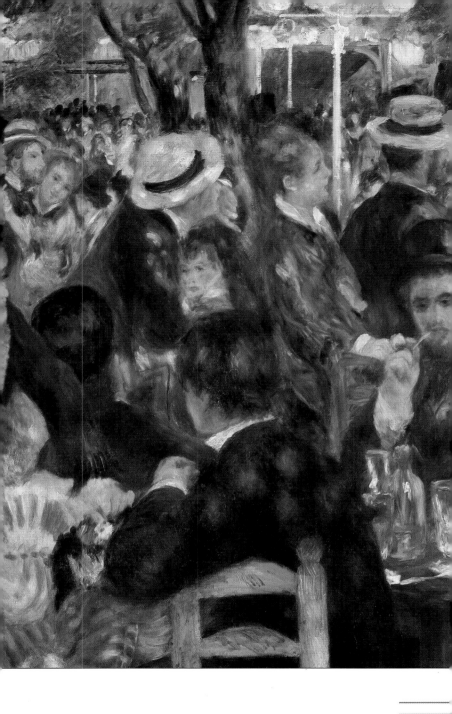

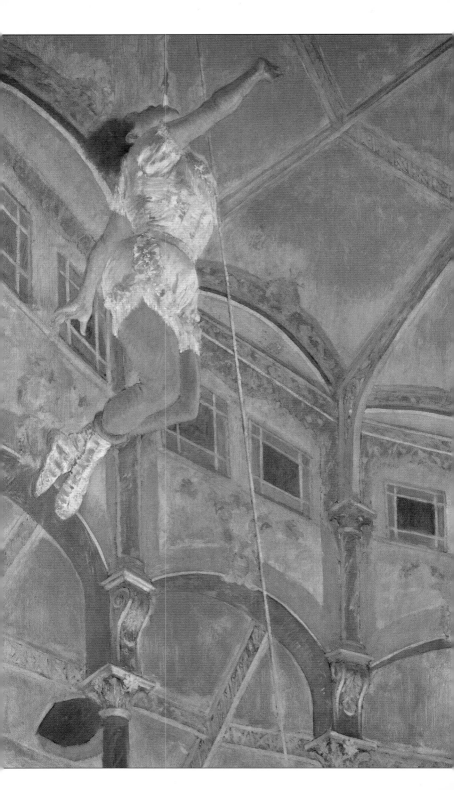

Lise was the model again for the two pictures that Renoir was fortunate enough to have had accepted by the Salon in 1870, just before the outbreak of the Franco-Prussian War, which could easily have terminated his promising career as it did that of his great friend Bazille. The two pictures show Renoir's divided aesthetic loyalties at this point. *The Bather with a Griffon* with its dull, earthy tonality and overly volumetric treatment of the nude body, shows Renoir's continuing interest in Courbet. *Odalisque* or *The Woman of Algiers* shows Lise dressed in exotic fashion and lying with half-closed eyes in an erotic daze, in a studio simulation of a harem. The picture is far more colourful with its flickering and divided brushwork and demonstrates a clear debt to Delacroix's famous *Women of Algiers* in the Louvre. Renoir had applied for permission to copy in the Louvre as early as 1860. Later he told his son Jean, "...while I was at Gleyre's, the Louvre for me meant Delacroix." It is astonishing to think that these two claustrophobic and rather retrogressive pictures were painted the year after Renoir painted his first sun-drenched and airy impressionist landscapes at La Grenouillere, alongside Monet. During the 1870s when Impressionism was at its height, Renoir painted fewer nudes than in any other decade of his long career. This probably has to do with the Impressionist commitment to painting outdoors.

36. Edgar Degas, *Mademoiselle Lala at the Cirque Fernando*, 1897, Oil on canvas, 117 x 77.5 cm, London, National Gallery

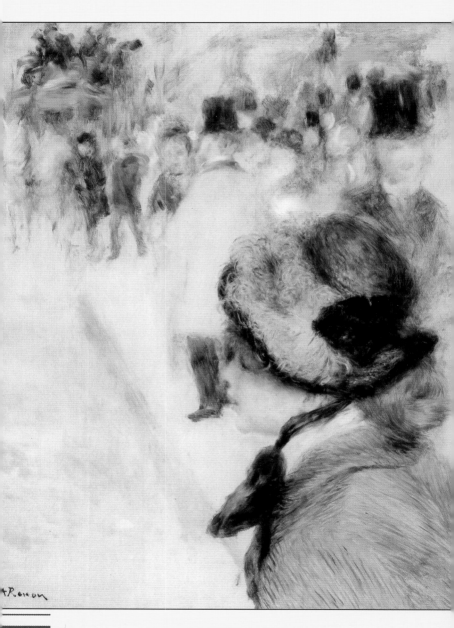

37. *La Place Clichy*, ca. 1880, Oil on canvas, 65 x 54 cm,
Cambridge, The Fitzwilliam Museum
38. Drawing for the illustration of *L'Assomoir* by Emile Zola,
1878, Pencil and ink, 24.5 x 37 cm

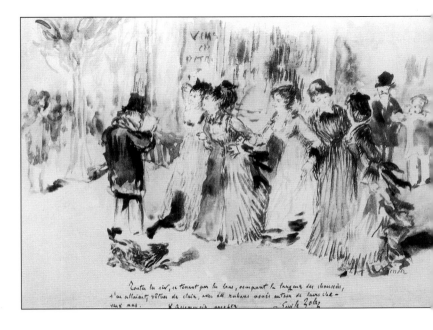

The practical problem of posing a nude model outside
the controlled studio environment was too great, not
to mention the moral outrage that would have ensued
in the nineteenth century from models taking off their
clothes in public places. A glorious exception is *Nude
in the Sunlight* which Renoir exhibited in the second
Impressionist exhibition in 1876.

The effect of sunlight breaking through foliage fascinated all the Impressionists in the 1870s, but was still disconcerting to the public and to the more conservative critics who were not used to seeing such effects represented in paintings. This was particularly so when the subject was that of the sacred female nude. The public was accustomed to the Salon nudes that seemed to be carved from marble or decorously wrapped in body stockings. The effect of shimmering, multi-coloured light and shadow on the flesh of Renoir's *Nude in the Sunlight* was perplexing. Albert Wolff, the critic of *Le Figaro*, described the nude as a "mass of flesh in the process of decomposition with green and violet spots denoting the state of a corpse's complete putrefaction!" Although many Salon artists began to paint outdoors in the last two decades of the century, trying to lend their works an air of truthfulness and modernity by imitating in a watered-down way some of the effects of the Impressionists, it was a long time before the uncompromising boldness of Renoir's *Nude in the Sunlight* was deemed acceptable. As late as the 1890s, the German Jewish writer Max Nordau whose notorious book *Degeneration* ironically became a blue-print for Nazi ideology on modern art, denounced a painting by Renoir of a woman (perhaps the very same *Nude in the Sunlight*) "on whose skin light and shadow play so unfortunately that she looks as if studded with putrescent corpse-stains of the second degree."

39. *The Box*, 1874, Oil on canvas, 80 x 63.5 cm, London, Courtauld Institute Gallery

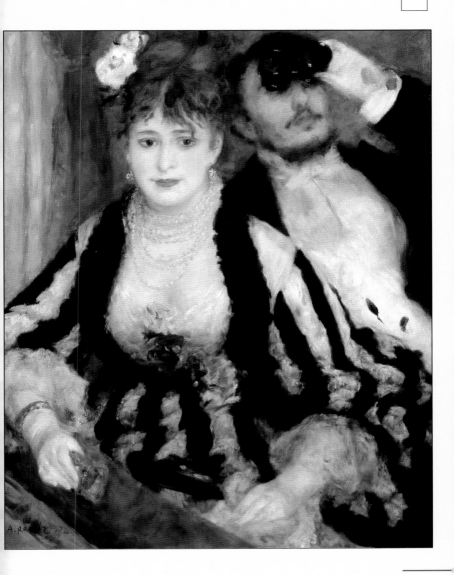

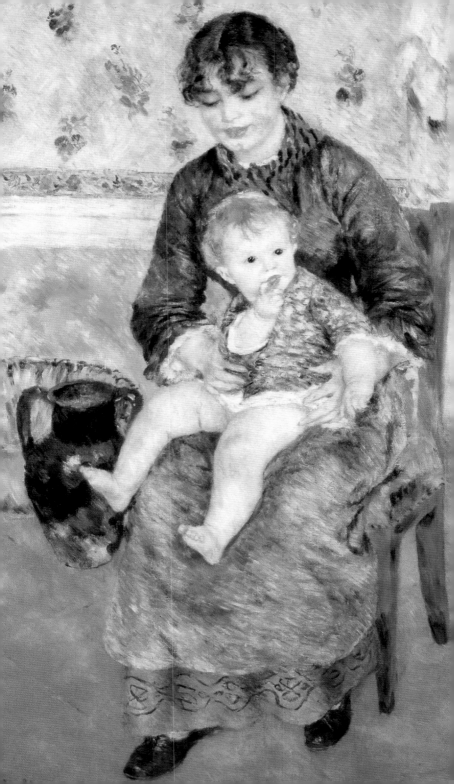

If Renoir painted fewer nudes during his
Impressionist phase, he continued to express his
love for the opposite sex more decorously in
portraits and in scenes of urban life. Still
unmarried and without a family to support, Renoir
could continue living in central Paris while his
fellow Impressionists Monet, Pissarro, and Sisley
had all moved out to the suburbs. Although he
certainly painted plenty of boating scenes, railway
bridges, and suburban villas on his day trips out of
central Paris, he also remained in the city centre to
paint the urban pleasures and pastimes favoured
by the slightly older painters of modern life such
as Manet and Degas. However, the depressing
mood of urban alienation captured so powerfully
by Manet and Degas, Caillebotte and later by such
visual chroniclers of urban life as Lautrec, Steinlen
and the young Picasso, did not interest Renoir at
all. Renoir's masterpiece in the genre of urban life
is the *Moulin de la Galette* (1876). It is instructive
to compare Renoir's version of this popular venue
with the sad and sinister versions produced later
by Picasso and the Catalan realist painter Ramon
Casas. Renoir's pretty girls all belong to the
familiar Renoir facial type and glow with rosey-
cheeked health and happiness. That they are all
prostitutes, or at the very least working girls of
easy virtue, is far from apparent.

40. *Mother and Child,* 1881, Oil on canvas,
12 x 85,4 cm, Mério (PA), The Barnes Foundation

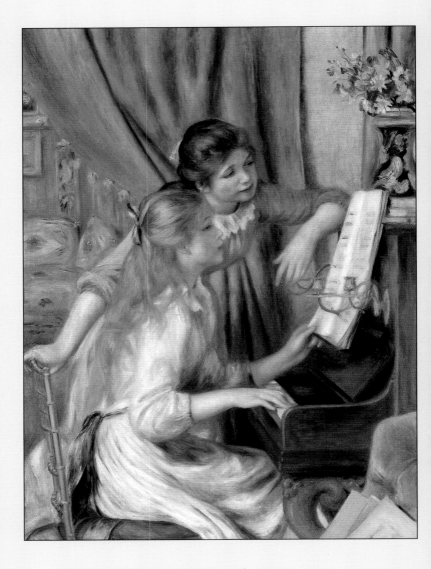

41. *Young Girls at the Piano*, 1892, Oil on canvas,
116 x 90 cm, Paris, Musée d'Orsay
42. *Yvonne and Chistine Lerolle at the Piano*, 1897,
Oil on canvas, 73 x 92 cm, Paris, Musée de l'Orangerie

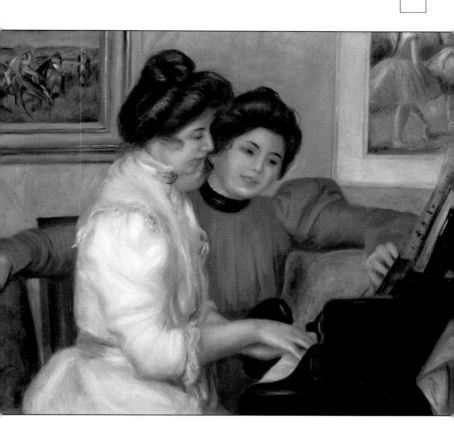

Prostitution was one of the principal themes of early
modernist art and literature in France. Unlike many
of his contemporaries, Renoir was not a regular
visitor of prostitutes, fearing the syphilis that was
such a scourge to nineteenth-century Paris.

When he saw the decline of his old friend, the composer Chabrier, as a result of this terrible disease, he exclaimed "Ah, those jades, it's better just to paint them". Although Renoir must have indeed painted many prostitutes at a time when modelling and prostitution were almost synonymous, he was not interested in the subject of prostitution as such. A rare exception is a pen and ink drawing he made in the late 1870s to illustrate Zola's novel *L'Assommoir* which also inspired notable paintings by Manet and Degas.

43. *Young Woman Playing the Guitar*, 1896-1897, Oil on canvas, 81 x 61 cm, Lyon, Musée des Beaux-Arts

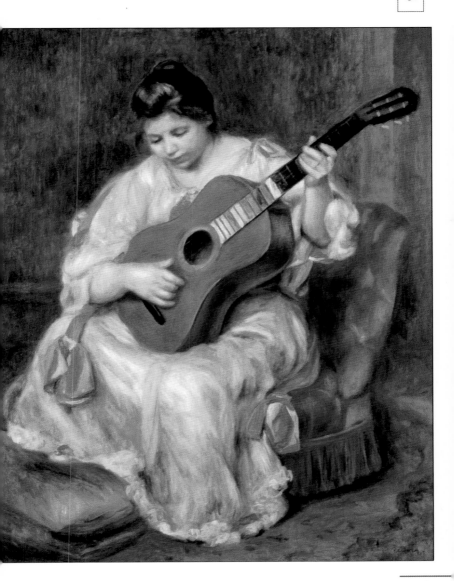

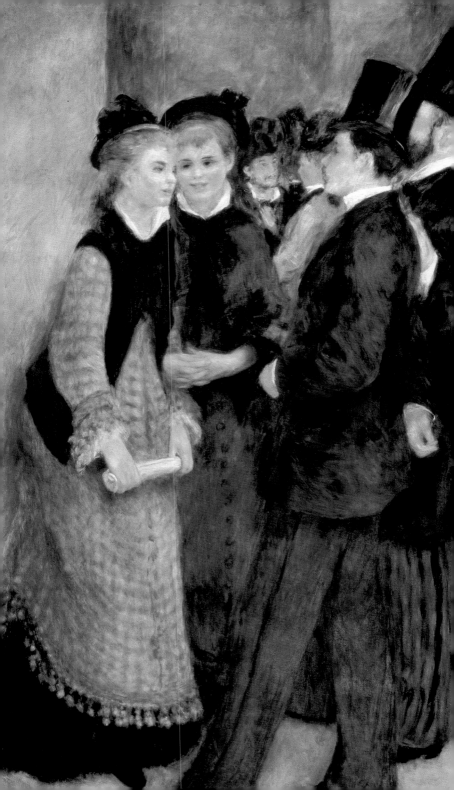

44. *The Exit of the Conservatory*, 1877, Oil on canvas, 187.3 x 117.5 cm, Merion (PA), The Barnes Foundation

La Loge (1874) and *First Outing* (1876) are amongst Renoir's most widely loved paintings. They invite inevitable comparisons with theatre scenes by Degas but once again there is a marked difference of emphasis. Renoir is less interested in conveying the atmosphere, the strange lighting and spatial effects of nineteenth-century theatre interiors and of the startling juxtapositions of reality and illusion and performance and audience that we find in Degas pictures. Instead he concentrates on conveying the charm and beauty of the female protagonists. The elegant but typically vacant-looking women in *La Loge* was one of his favourite models of the period, Nini Lopez.

Her male companion (for which Renoir's brother Edmond posed) is clearly ogling another woman on the other side of the theatre through his opera glasses. The depiction of the generic Renoir girl in *First Outing* hovers on the brink of sentimentality in a manner that might have irritated Degas. The sophistication and elegance of the woman in *La Loge* anticipates a group of commissioned portraits that Renoir painted just before and after 1880. Although born into very humble circumstances, Renoir possessed a simplicity and charm that enabled him to cross all class barriers. In the late 1870s Renoir gained entrée to fashionable society through the salon of Mme Charpentier, the wife of a wealthy publisher. Renoir's portrait of Mme Charpentier and her two children gained him his first major public success in the 1878 Salon and led to further commissions from the banking family Cahen d'Anvers. Though a man of simple tastes, Renoir relished the opportunity to paint beautiful women and their children in opulent surroundings. The success of these gorgeous, densely-painted portraits with their sumptuous clothing and elaborate props, could have *led* to a lucrative career as a fashionable portraitist if Renoir had been so inclined. It was not to be, although in later years, rather like Ingres, Renoir was always prepared to paint fashionable women if they appealed to him physically.

44. *The Exit of the Conservatory*, 1877, Oil on canvas,
187.3 x 117.5 cm, Merion (PA), The Barnes Foundation

La Loge (1874) and *First Outing* (1876) are amongst
Renoir's most widely loved paintings. They invite
inevitable comparisons with theatre scenes by Degas
but once again there is a marked difference of
emphasis. Renoir is less interested in conveying the
atmosphere, the strange lighting and spatial effects of
nineteenth-century theatre interiors and of the
startling juxtapositions of reality and illusion and
performance and audience that we find in Degas
pictures. Instead he concentrates on conveying the
charm and beauty of the female protagonists. The
elegant but typically vacant-looking women in *La Loge*
was one of his favourite models of the period, Nini
Lopez.

Her male companion (for which Renoir's brother Edmond posed) is clearly ogling another woman on the other side of the theatre through his opera glasses. The depiction of the generic Renoir girl in *First Outing* hovers on the brink of sentimentality in a manner that might have irritated Degas. The sophistication and elegance of the woman in *La Loge* anticipates a group of commissioned portraits that Renoir painted just before and after 1880. Although born into very humble circumstances, Renoir possessed a simplicity and charm that enabled him to cross all class barriers. In the late 1870s Renoir gained entrée to fashionable society through the salon of Mme Charpentier, the wife of a wealthy publisher. Renoir's portrait of Mme Charpentier and her two children gained him his first major public success in the 1878 Salon and led to further commissions from the banking family Cahen d'Anvers. Though a man of simple tastes, Renoir relished the opportunity to paint beautiful women and their children in opulent surroundings. The success of these gorgeous, densely-painted portraits with their sumptuous clothing and elaborate props, could have *led* to a lucrative career as a fashionable portraitist if Renoir had been so inclined. It was not to be, although in later years, rather like Ingres, Renoir was always prepared to paint fashionable women if they appealed to him physically.

45. *The First Outing*, ca. 1876, Oil on canvas,
65 x 49.5 cm, London, The National Gallery

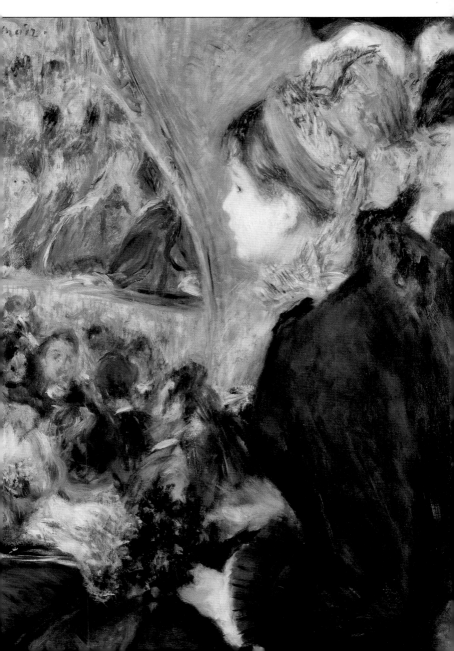

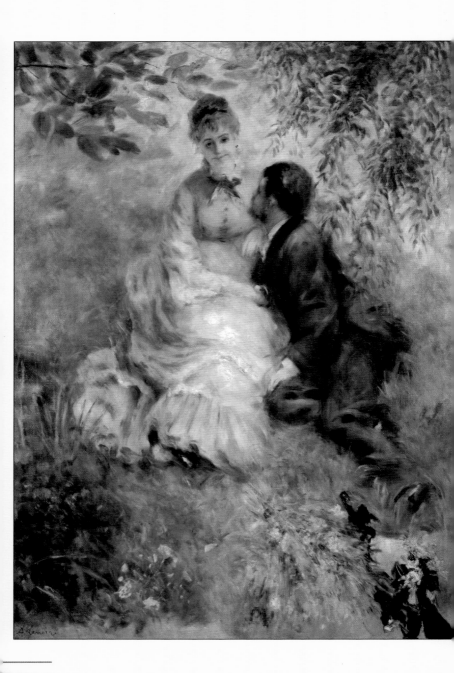

The final masterpiece of Renoir's Impressionist phase was Boatman's Luncheon, painted between 1880 and 1881. Signs of impending change are already visible: The awning under which the figures sit, creates a more even light than that in *Moulin de la Galette* painted five years earlier. Contours are more firmly defined and the shimmering light no longer threatens to dissolve solid forms. This great painting documents Renoir's burgeoning love for his future wife Aline Charigot who posed as the charming girl on the left, playing with a small dog.

46. *The Lovers*, ca. 1875, Oil on canvas, 175 x 130 cm, Prague, Nàrodni Galerie v Praze

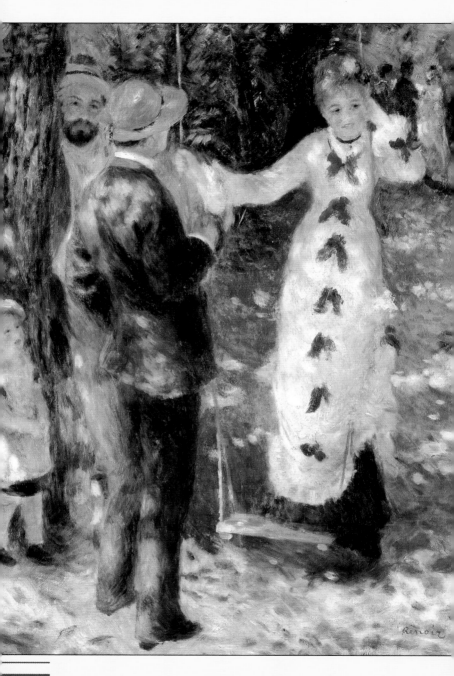

47. *The Swing*, 1876, Oil on canvas, 92 x 73 cm, Paris,
Musée d'Orsay

Her full, wide mouth and short, *retroussé* nose
correspond perfectly to Renoir's ideal of feminine
beauty. The young woman on the right of the picture
is Ellen Andree, a lifelong friend of the artist who
began humbly as an artist's model (posing for Degas
and academic artists like Gervex) and a common
prostitute, but went on to have a long and
distinguished career as an actress.

In 1881 Renoir set off for Italy, taking the deliciously plump Aline Charigot with him. According to Renoir she posed in a boat in the Bay of Naples for one of his loveliest nudes *The Blonde Bather*, now in the Sterling and Francine Clark Art Institute in Williamstown. It is hard to imagine that this young girl would have placed her immaculately pink and white skin at risk under the fierce Neapolitan sunlight. There are none of the ephemeral effects of open air, light, and atmosphere that Renoir had captured in the *Nude in the Sunlight* of 1874.

Renoir's 1881 Italian trip marks the beginning of a crisis of confidence that would last the better part of ten years. As Renoir put it later, "I had exhausted Impressionism and finally came to the conclusion that I could neither paint nor draw." The most striking document of this artistic crisis is his famous painting *The Umbrellas* in the London National Gallery. The shop-girl on the left carrying a hat box and the bourgeois woman on the right looking after her children, belong to the same family of Renoir's women, but seem to have been painted by different hands – the woman on the right in the fluffy, broken brushwork of the Impressionist phase and the shop-girl on the left in his new hard-edged and rigidly disciplined style of the 1880s.

48. *The Promenade*, 1870, Oil on canvas, 80 x 64 cm, Los Angeles (CA), The J. Paul Getty Museum

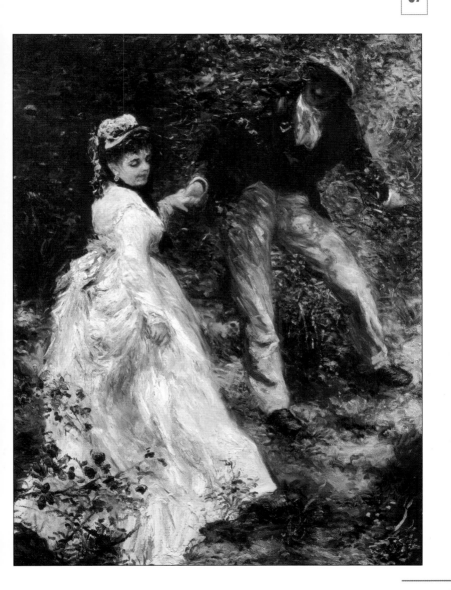

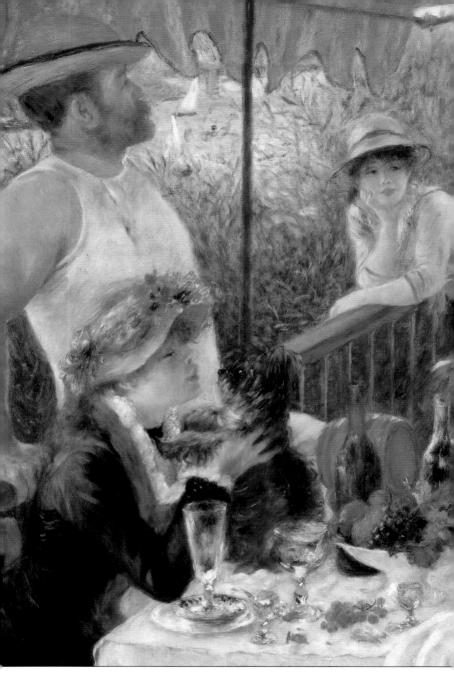

49. *The Lunch of the Boaters*, 1880-1881, Oil on canvas, 129.5 x 172.5 cm, Washington (DC), The Philipps Collection

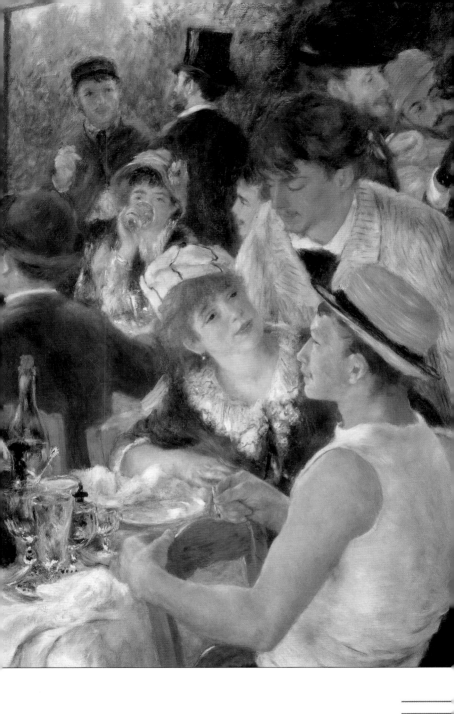

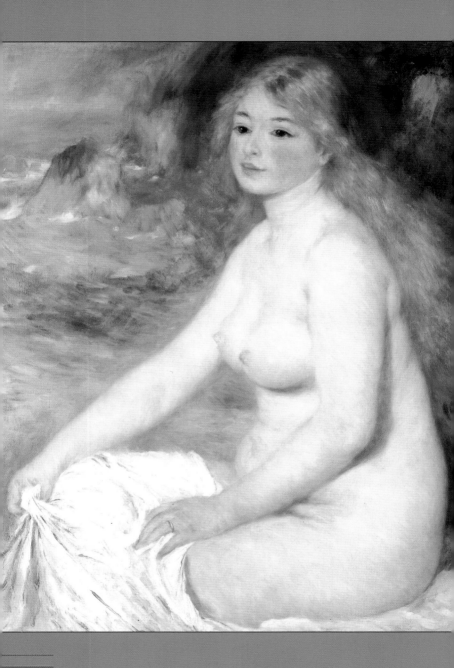

This new "dry style" as Renoir himself termed it, found its apogee in *The Large Bathers* (1887). This is a curious work. Undoubtedly impressive, it nevertheless lacks the charm and spontaneity that characterise Renoir's more popular works. In many ways it seems like a return to those formulaic, academic nudes so despised by the Impressionists. Renoir's friend Pissarro was disconcerted and wrote to his son "I do not understand what he is trying to do, it is not proper to want to stand still, but he chooses to concentrate on line, his figures are all separate entities, detached from one another without regard for colour."

50. *Blond Bather*, 1881, Oil on canvas, 82 x 66 cm, Williamstown (MA), Sterling and Francine Clark Art Institute

Renoir finally overcame his artistic crisis around 1890 and from this time on his style evolves confidently and without interruption until his death in 1919. The small *Bather Arranging Her Hair* of 1887-1890 in the London National Gallery shows all the elements of his later style already in place. The hard edges of his "dry style" have given way to a soft, caressing application of paint. The paint surface has taken on that lovely pearly quality that would characterise Renoir's work for the rest of his life. Though the woman sits outdoors, his concern with the weight and volume of the figure now takes precedence over the rendition of light and atmosphere. *Bather Arranging Her Hair* has a timeless monumentality and visitors to the National Gallery already familiar with the work through reproductions can only be surprised by its tiny size. A pastel of a *Toilette* by Degas, hanging in the same room, shows a nude awkwardly twisting as she dries her hair. Seated upon an upholstered chair in front of a hip bath and wearing slippers, this image reminds us of the improbability of any nineteenth-century woman taking off her clothes in a garden and sitting on a rock or tree stump to arrange her hair. By this stage however, Renoir is no longer interested in *verisimilitude.*

51. *La Coiffeuse (Bather Arranging her Hair)*, 1885, Oil on canvas, 92 x 73 cm, Washington(DC), National Gallery of Art, Chester Dale Collection

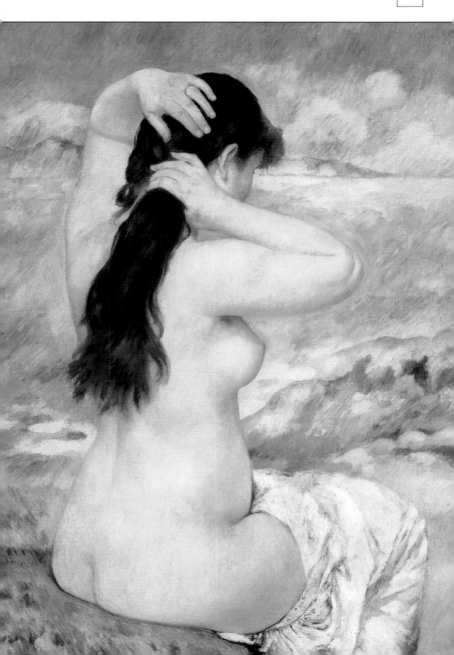

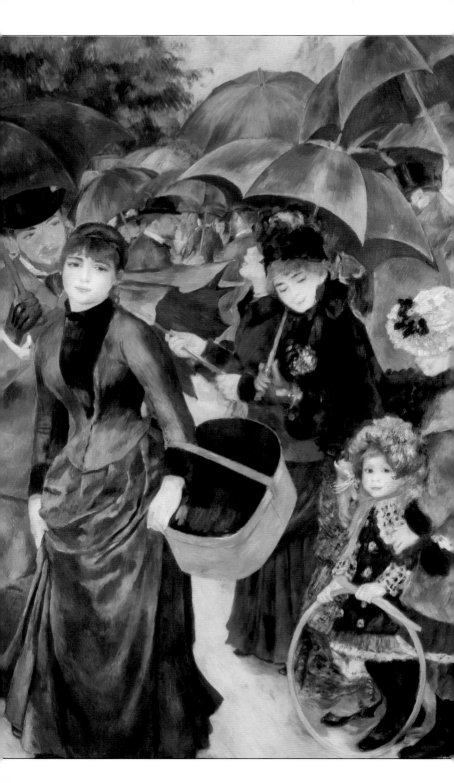

Many of the nudes during Renoir's final years are of his model Gabrielle Renard, a cousin of Mme. Renoir who brought her from her home village at the time of Jean Renoir's birth in 1894 to look after the new baby. She comfortably and serenely combined the roles of nursemaid and model, often posing partially clothed, exposing one or both breasts. Despite her generous and very feminine curves, Gabrielle also replaced a male model and posed as Pâris in the 1908 painting of *The Judgement of Paris*. Renoir found himself uncomfortable with the muscularity of the male model he had originally chosen. The knotty complexity of the male anatomy was at odds with the larger and simpler volumes that Renoir increasingly favoured in later years.

Renoir's late style reached its culmination in the monumental (110 x 160 cm) painting *The Bathers* completed in 1919, the year of his death. According to his son Jean, Renoir regarded this great painting as his artistic testament and a summation of his life's work. The model for this picture was the pretty redhead Andree Heuschling (later Hessling) who would brighten Renoir's final years with her insouciance and her habit of singing "slightly off-key, the popular songs of the day".

52. *The Umbrellas (After the Rainfall)*, ca. 1881-1885, Oil on canvas, 180.3 x 114.9 cm, London, The National Gallery

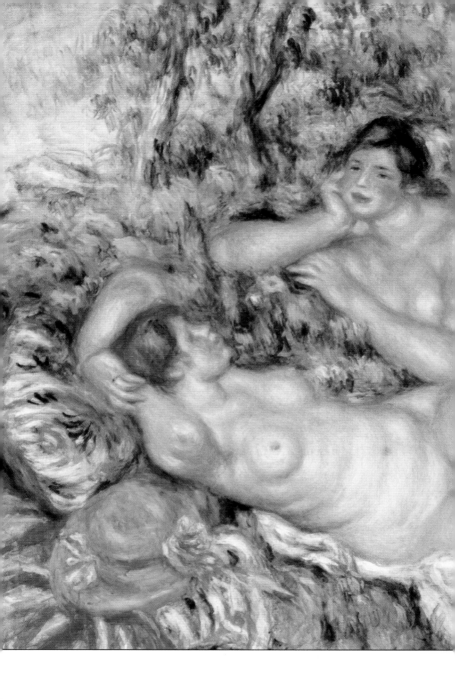

53. *The Bathers*, 1918-1919, Oil on canvas, 110 x 160 cm,
Paris, Musée d'Orsay

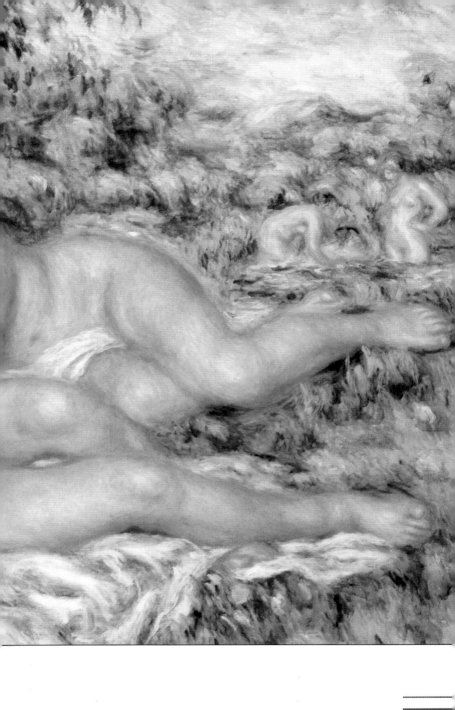

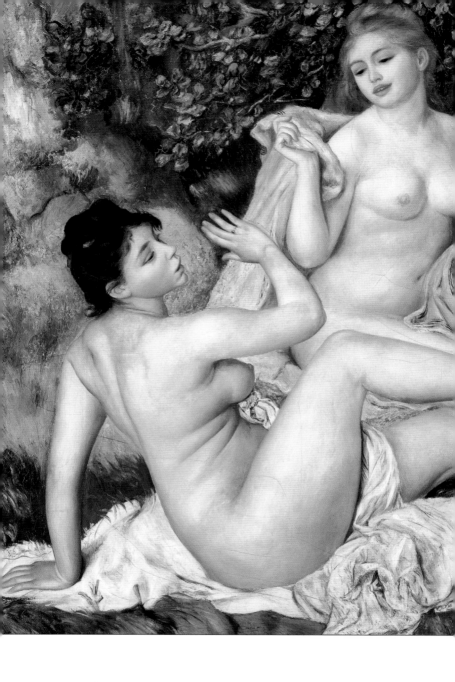

54. *The Great Bathers*, 1887, Oil on canvas, 115 x 170 cm,
Philadelphia (PA), Philadelphia Museum of Art,
The Mr. and Mrs. Carroll S. Tyson Collection

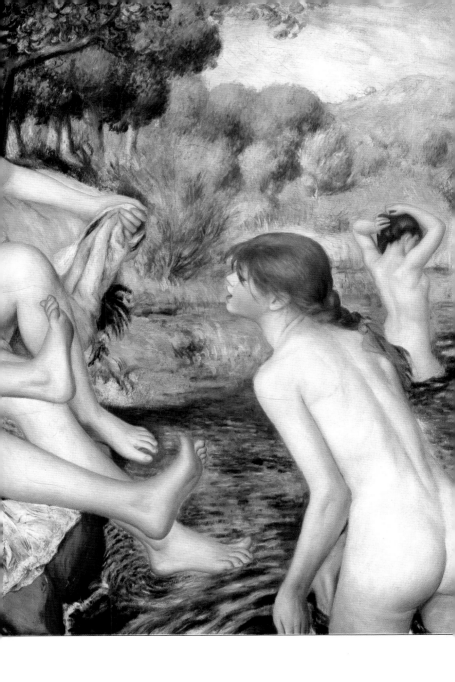

It was Henri Matisse who had taken one look at the young model and pronounced "You're a Renoir" and sent her off to the older artist. Matisse's judgement proved correct and Renoir claimed that Andree's skin "took the light" better than that of any other model. Jean Renoir who would later marry Andree and launch her career as a silent film star, described her appearance somewhat unflatteringly, saying that she had "almost white eyes like a pig's" and "a big behind and short legs." The contrast between this exuberantly healthy girl and the crippled and pathetically frail artist as she placed the brush in his bandaged hand, must have been poignant. After Renoir's death, the French state initially refused this painting as a gift from the artist's sons and it is a painting that continues to arouse controversy. It offends the modern canons of female beauty and feminist sensibilities with its depiction of women with cushion-like, almost vegetal passivity. The soft, swelling, boneless bodies are disturbingly reminiscent of inflated dolls. It is hard to imagine whether women are standing up and walking or even moving of their own volition. By contrast, the aged painter's application of paint is astonishingly fluid and vigorous. According to Matisse, as repeated by Frank Harris, Renoir commented while painting the two women's bodies, that they were

55. *The Nude*, 1876, Oil on canvas, 92 x 73 cm, Moscow, The Pushkin Museum of Fine Arts

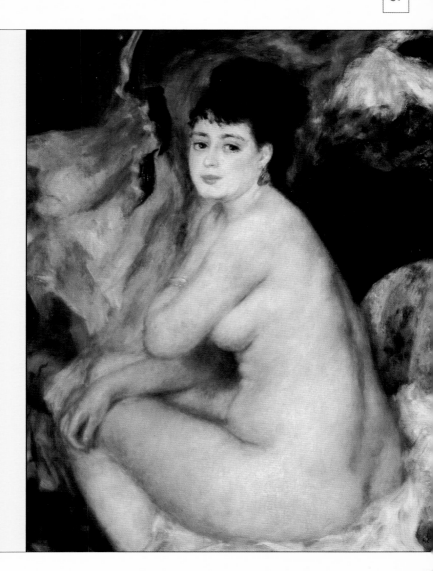

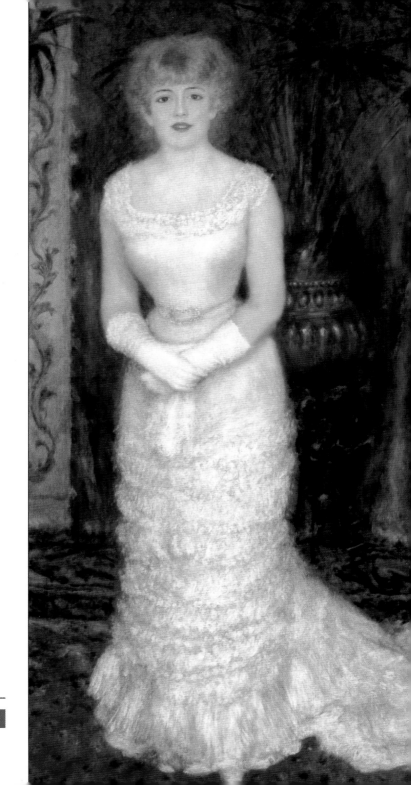

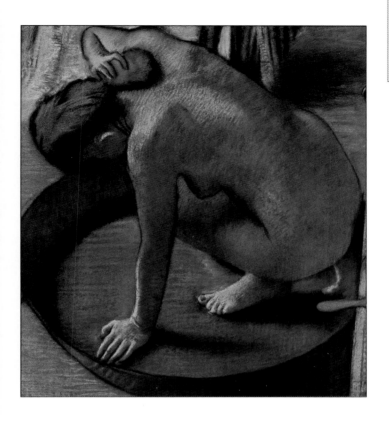

"God's best works…His supreme
achievement. The pain passes" he said
"but the beauty remains. I'm quite happy
and I shall not die until I have
completed my masterpiece."

56. *The Actress Jeanne Samary*
57. Edgar Degas, *The Tub*, 1886, Pastel, 60 x 83 cm, Paris,
Musée d'Orsay

58. *After the Bath*, 1912, Oil on canvas, 67 x 25.5 cm,
Winterthur, Kunstmuseum

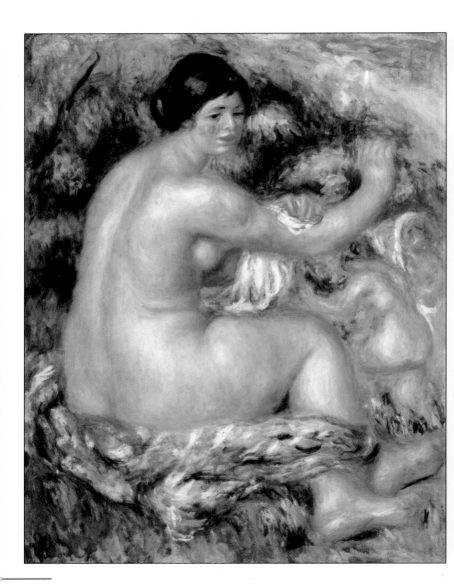

59. *Bathers Brushing their Hair*, 1893, Oil on canvas,
92.5 x 74 cm, Washington (DC),
National Gallery of Art, Chester Dale Collection

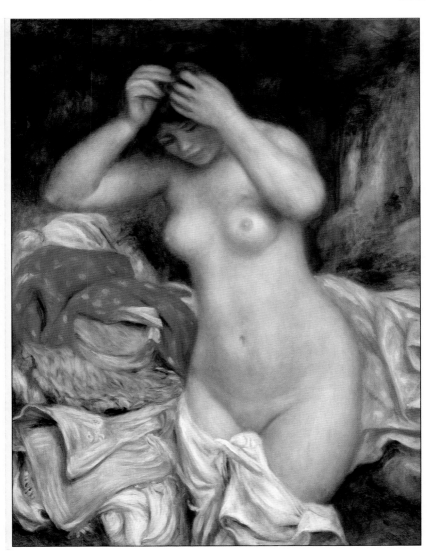

INDEX